HIGH PINK

HIGH PINK

Tex–Mex Fairy Tales

by

Franco Mondini-Ruiz

d·a·p

D.A.P. / Distributed Art Publishers, Inc.

DOWNTOWN **arts** PROJECTS

High Pink
Tex-Mex Fairy Tales by Franco Mondini Ruiz
© 2005 by D.A.P./Distributed Art Publishers, Inc.

All artwork courtesy of Frederieke Taylor Gallery.

Interior photographs courtesy of Frederieke Taylor Gallery and
UCLA Fowler Museum of Cultural History.
Cover photograph by John Engstrom.

Design and typesetting by Carole Goodman / Blue Anchor Design

Printed by Oceanic Graphic Printing Inc., China.

Published by

D.A.P. / Distributed Art Publishers, Inc.
155 Sixth Avenue, Second Floor
New York, NY 10013
Tel: 212.627.1999

in conjunction with

Downtown Arts Projects, Inc.
114 Fulton Street , Suite 5E
New York NY 10038

This publication is made possible in part by
generous grants from the New York State Council
for the Arts and the Creative Capital Foundation.

NYSCA

First Edition
ISBN 1-933045-12-4

Available through
D.A.P. / Distributed Art Publishers, Inc.
1-800-338-2665
www.artbook.com

For my Mother, the Keeper of Cakes . . .

✳

Still Life with Potatoes, Pearls, Raw Meat, Rhinestones, Lard, and Horse Hooves

SANDRA CISNEROS

In Spanish it's *naturaleza muerta* and not life at all.

But certainly not natural. What's natural?

You and me. I'll buy you a drink.

To a woman who doesn't act like a woman.

To a man who doesn't act like a man.

Death is natural, at least in Spanish, I think.

Life? I'm not so sure.

Consider The Contéssa, who in her time was lovely

and now sports a wart the size of this diamond.

So, *ragazzo,* you're Venice.

To you. To Venice.

Not the one of Casanova.

The other one of cheap pensiones by the railway station.

I recommend a narrow bed stained with semen, pee, and sorrow
 facing the wall.

Stain and decay are romantic.

You're positively Pasolini.

Likely to dangle and fandango yourself to death.

If we let you. I won't let you!

Not to be outdone I'm Piazzolla.

I'll tango for you in a lace G-string

stained with my first-day flow

and one slopply tit leaping like a Niagara from my dress.

Did you say duress or dress?

Let's sing a Puccini duet—I like *La Traviesa*.

I'll be your trained monkey.

I'll be sequin and bangle.

I'll be Mae, Joan, Bette, Marlene for you—

I'll be anything you ask. But ask me something glamorous.

Only make me laugh.

Another?

What I want to say, *querido,* is

hunger is not romantic to the hungry.

What I want to say is

fear is not so thrilling if you're the one afraid.

What I want to say is

poverty's not quaint when it's your house you can't escape from.

Decay's not beautiful to the decayed.

What's beauty?

Lipstick on a penis.

A kiss on a running sore.

A reptile stiletto that could puncture a heart.

A brick through the windshield that means I love you.

A hurt that bangs on the door.
Look, I hate to break this to you, but this isn't Venice or Buenos
 Aires.
This is San Antonio.
That mirror isn't a yard sale.
It's a fire. And these are remnants
of what could be carried out and saved.
The pearls? I bought them at the Winn's.
My mink? Genuine acrylic.
Another drink?
Bartender, another bottle, but—
¡Ay caray and oh dear!—
The pretty blonde boy is no longer serving us.
To the death camps! To the death camps!
How rude! How vulgar!
Drink up, honey. I've got money.
Doesn't he know who we are?
Que vivan los de abajo de los de abajo,
los de rienda suelta, the witches, the women,
the dangerous, the queer.
Que vivan las perras.
"Que me sirvan otro trago . . ."
I know a bar where they'll buy us drinks
if I wear my skirt on my head and you come in wearing nothing
but my black brassiere.

Infinito Botanica

"Amor, dinero, y salud, y el tiempo para gozarlo."
—Mexican dicho painted on the side of Infinito
Botanica's building, San Antonio, Texas

I FIRST MET FRANCO IN THE KITCHEN OF HIS GENESEO
Street house. He was living the life of a successful lawyer then. I had my
hands in sudsy water and was furiously washing dishes the moment he
poked his head in the kitchen door and introduced himself. His houseguest
had invited us over for an impromptu party, and I remember our panic try-
ing to get the house clean again before Franco walked in from an out-of-town
trip. There was no need to worry, I would later find out. His house was
always full of strangers. He never locked the doors. Often, beautiful boys fell
asleep there, and more often beautiful boys ripped him off. He lived like an
Italian movie, part Fellini, part Pasolini. This was part of *el mundo Mondini,*
a chapter of my life that was to run its course the decade of the nineties.
Falling into Franco's life was like falling into Alice in Wonderland's rabbit
hole. The house on Geneseo was famous for parties where wealthy little old
ladies in gold lamé might appear, as well as six-foot-tall transvestites, and a
parade of live chickens. But Franco's most remarkable feat would be the
alchemy of *Infinito Botanica,* a crumbling Mexican magic shop filled with

folk medicine as well as high art. It was the only place in the city where a working-class person might hobnob with a millionaire. Rich Houston ladies shopped alongside tatooed *vatos*, big Botero-esque babes from the southside dyke bars, Mexican *nationals* dressed in impeccable designer wear, Mexican illegals sweaty from hard labor, and the neighborhood Catholic priest. Everyone was welcome. In a sense, it was like one of Franco's parties, high/low or high/rascuache. To be fair, the predecessor of this high-camp living was a man who had inspired us all and introduced us to each other. Danny Lopez Lozano of Tienda Guadalupe Folk Art. It was Danny who provoked a generation of Chicano artists to relook at the *bueno, bonito, y rascuache* of San Antonio and transform it into glamour. The gatherings at his shop on South Alamo Street, as well as at his parties at his home, became our salon. If anyone was our mother, it was Danny, and we belonged devotedly to the House of Guadalupe. When Danny died of throat cancer in 1992, it was up to other artists to carry the torch. Franco stepped in with *Infinito Botánica* on South Flores Street. Other artists followed living upstairs or next door, so that when an arts event occured, it involved several open studios and the space in between. Anything could happen and often did. Performances on the sidewalk spilling onto the street. Backyard cookouts featuring feasts more magnificent than Moctezuma's. A spontaneous eruption of Pancho Villa mustaches painted on the women and Frida eyebrows on the men. Some of us aren't speaking to each other anymore, but for a time not only were we speaking, we were singing arias. Whatever inspired one of us, was sure to inspire us all. An outbreak of Buddha art, Day of the Dead altars, Maria Callas look-alike nights, *Paquita la del Barrio*. Oh, honey, do I have to tell you? Franco taught us to play. At the Liberty Bar, the name wasn't just a name, it was a way of life. We

might compete for the same boys: "You can have him after me," a fight might break out over *mole;* from a jar versus from scratch. But we did see the world through the same rose-tinted glasses called Mexican-nostalgia. Franco taught me to see beauty in pink cupcakes, plastic champagne cups filled with colored water, Mexican pan dulce adorned with pre-Columbian artifacts. I still have the Marie Antoinette living room set I bought at *Infinito*, full of woodworms and horsehair stuffing, chairs so uncomfortable, they're not for sitting. That was then. Before 9-11. Before we started getting harassed for looking like the Arab Jews we are. We were escape artists in our escapades, looking for a shortcut to Berlin or Buenos Aires, trying to make high glam from whatever we had on hand. Those times. As a drunk woman so aptly put it at the final *Infinito* party, "It's the end of an error."

Sandra Cisneros
Sept 11, 2004
San Antonio de Béxar, Texas

Rosa Mexicana (Mexican Pink)

1971. We are in the fifth grade in Floresville, Texas—home of the world's largest peanut. Rosa weighs in at nearly two hundred pounds. And as if that isn't painful enough, she wets her pants on class photo day.

The final humiliation comes when we get the pictures back. Rosa's eyes are slightly crossed and there's a trickle of urine on the cement steps.

Poor Rosa. Her parents must be workers from Mexico or they would have known better than to give her a maid's name. They would have named her Rose, like other Floresville girls. Or better, Rosie, so she could have been fun and popular like Rosie Benavides and signed her name with a fabulous circle over the i.

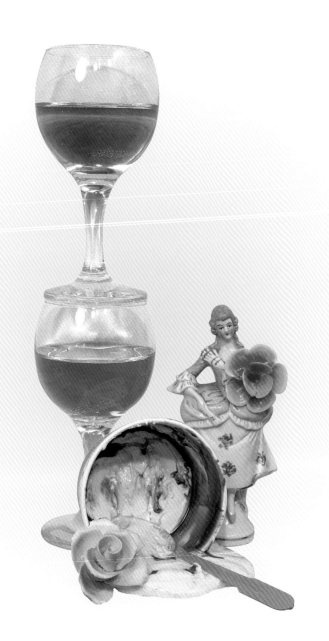

Miss Valdez

�֍

Miss Valdez could always be counted on to add a classy and extravagant touch to Bambi's New Year's Eve parties in San Antonio—perhaps an innovative flourish of napkin, or the latest techno-pop from Monterey. Stylish and dependable, she was a hit at her day job as the maître d' of the officer's club on the base.

After Bambi died, Miss Valdez started spending most nights at the Pegasus, her friend Bullfrog's new club, which was in a converted Conoco station across from the cruise park on Evergreen.

I would always find her in front of that horrific hand-painted mural of a winged teal horse with backward hooves. "Miss Valdez!" I would call through the swirling smoke, the Hilfiger cologne, the cherry bathroom deodorizer, and the blare of Madonna.

She would spiral elegantly under a tight halogen spotlight and beckon me for a cocktail. Always top-shelf. Always glamorous.

Sabor a Mí (A Taste of Me)

❦

This sumptuously romantic Mexican classic was composed by Alvaro Carrillo and was made famous in the U.S. by Eydie Gormé. A lot of us upwardly-mobile Tex-Mex gay boys have gravitated toward the lush, gardenia-scented Mexican golden era of the 30s and 40s that this song evokes. Drunk on its glamour, some of us have gone so far as to have Mexican boyfriends—Mexican *nationals*—the high-class ones with the green eyes and the shirts made in London, the type that a generation ago would have had nothing to do with us Tex-Mex *pochos* who can't speak Spanish or even correctly pronounce our own last names.

Where I come from, having a taste of a Mexican prince is a painful rite of passage. But who can blame us? They know the silky lyrics to all the heart-wrenching *boleros;* they light our cigarette with a silver lighter, like James Bond; they grew up in the largest city in the world, in modern stone-and-glass palaces designed by Luís Barragán. They can even dance real dances—and with real girls! And best of all, they're not white guys—they're Mexicans, just like us.

Consider yourself warned my friend. When you least expect it, the Mexican prince will pierce your naive, Americanized heart with that fancy fish-fork of his. He will stop returning your calls; the maid will answer the phone. And you'll spend years convincing yourself he was just a cheeseball.

White Shoulders

✾

Dear Madams,

At the risk of appearing colonized *and* patronizing, and maybe even of sounding like the lyrics to a Julio Iglesias song, I would like to thank those of you who have helped me and others of my kind arrive at this most agreeable place.

True to your convictions, you have so often opened the closed doors of art, culture, and social mobility, shouldering with grace and aplomb the Pandora's box of consequences.

I hope I shall be even half as successful when called upon to do the same.

Your humble servant,
Franco Mondini-Ruiz

La Vie En Rose

✳

1987. Grace Jones, no one ever told me I'm allowed to enjoy my life.

God, if you exist, thank you. Universe, I most humbly thank you. Holy ancestors who gave me this life, I love you and thank you. Tonight I am young, rich, pretty, and in love. I am French kissin' in the U.S.A. "Are you guys comin' to my Blondie party?"

I am never coming down.

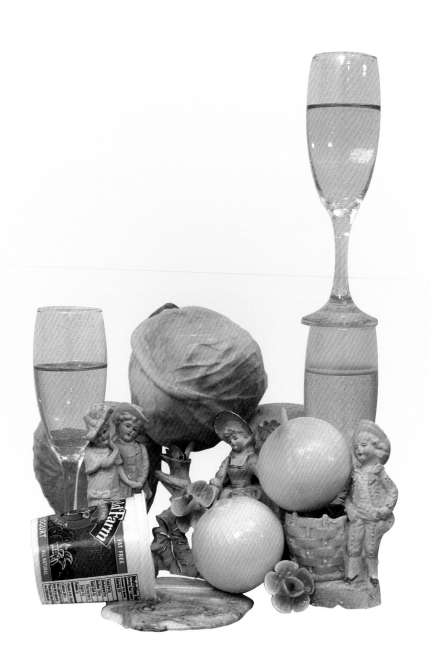

CHERRY VANILLA

Cherry Vanilla was a somebody in the early days of Andy Warhol's fierce galaxy of queer superstardom.

I wonder what Warhol would have thought of me. I wonder if I would have been allowed into that world. You must admit, the Factory was pretty much a white thing, even if it was a Catholic white thing. I don't recall many Latinos in that scene. And I remember reading once that Warhol was terrified of black people.

Oh well, I probably would have tried to pass for a white guy back then anyway.

While Cherry Vanilla was enjoying her swirl, César Chávez was uniting *la raza* in the fertile fields of Southern California. I wonder if I would have been allowed into that world. From what I hear, it was pretty much a macho thing. Homophobic.

Oh well, I probably would have tried to pass for a straight guy back then anyway.

Juan Diego

On December 12, 1523, a frightened Indian named Juan Diego scurried up Mount Tepeyac, on the then outskirts of Mexico City. When he reached the top, he fell to his knees and breathlessly told the Virgin of Guadalupe that the Spanish priests did not believe he had seen her the day before. They were angry at his "outrageous lies." So the Virgin gave him red roses, which were out of season, as proof. He wrapped them in his cloak and scurried down the mountain.

When he unrolled his cloak, the priests beheld an astonishing vision: a caramel-skinned *virgencita* standing on a crescent moon.

Four centuries later, little Juan Diego has finally been canonized. He is one of only a handful of indigenous caramel-skinned people of the New World to receive this holy distinction.

I guess all those pink-skinned Old World saints need someone to haul out the trash up there.

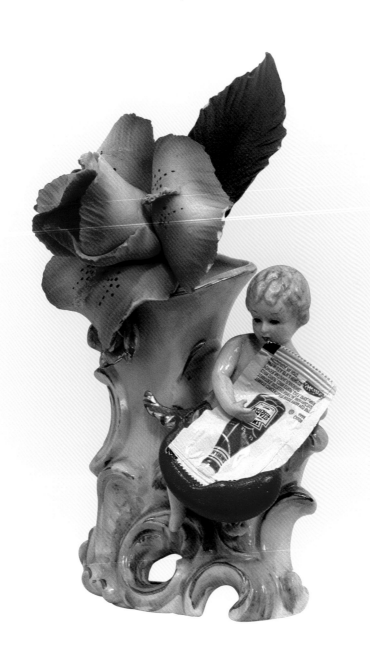

Don't Tell Grandma

No one on earth is more spoiled than a Tex-Mex grandson. He's even more regally indulged than a Jewish or Chinese grandson. Just spoiled rotten. Doesn't even have to go to school if he doesn't want to. He can just stay home with Grandma Ruiz and eat French-fries for the rest of his life. Top that!

But that's my older brother's story, not mine. Dad finished his high-class NATO gig in Rome just in time to rescue us from Grandma's dead-end, Tex-Mex matriarchy of chain-link fences, pregnant dogs, and coffee-can gardens. He delivered us safely into his Italian-American patriarchy of central air, carpet grass, and wood paneling. In that space-age suburb, I never got to do anything I couldn't tell a grandma about.

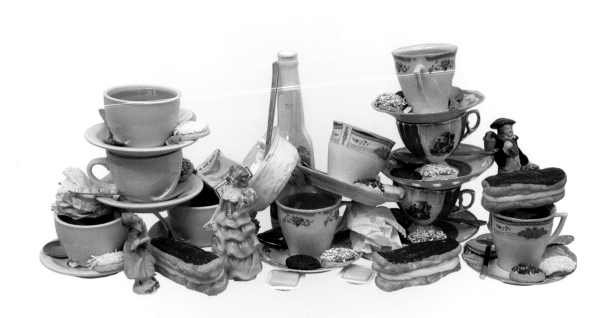

Katty Kupple

Despite their fancy poodle names, Ignatius and José Alexis are a very catty couple. For starters, they never invite me to their annual Christmas party, even though they always come to mine. Maybe Ignatius thinks he's better than me because he's a descendant of Mexican aristocracy and his grandfather was the private physician to Porfirio Díaz. Or maybe it's just that he knows I've slept with José Alexis—more than once.

La Boda (The Wedding)

Ricardo Martinez was real proud of the fact that he grew up in Castle Hills, which was the "rich Mexican" district of San Antonio back in the 70s. I met him after his dad had squandered the family fortune. Ricardo was living with his mother, grandmother, and sister in a small government-subsidized apartment full of ornately carved furniture, bad Persian carpets, and old shopping bags stuffed with the debris *de lujo* of the fallen nouveaux riche.

A stout, beaming, brown-skinned woman named Chata silently catered to our every need. I remember thinking how cool it was that Chata had stayed with them even though they probably couldn't afford to pay her much, if at all.

For lunch, Chata served us tuna-fish sandwiches, Ruffles, homemade refried beans with crumbly Oaxacan cheese, and iced tea. Dessert was a grand Sara Lee cheesecake topped with sliced mango marinated in rum and cinnamon.

Several months into my courtship with Ricardo, he tearfully admitted that the apartment was Chata's.

The Blue Room

✦

During the first Bush administration, my friend Rolando Briseño and his very accomplished family were invited to the White House to be honored during Hispanic Heritage Month.

I don't remember the whole story, but I do recall Rolando saying that they had tea and lemonade with Barbara Bush in the Rose Garden. He said they mostly just kinda sat there while she talked to her dog the whole time.

I Hope We're Not Late

❖

We Mexicans are always late. I hope this time we're not too late, now that we are finally ready to get back in touch with the land of our heritage.

Our Tex-Mex parents and grandparents wouldn't have dreamed of it. "Why would you want to go back there? It's dangerous. You'll get sick. You'll get arrested!"

So, here we are in Mexico City. Wow! Is that a four-story Gucci boutique? Is that a pyramid in the subway? And what are all these British and German and gringo-American hipsters doing here? I hope they're just here for the silver and the *mole,* not to also get in touch with the land of our heritage. But if they are, I hope they leave us some.

I knew we shouldn't have gotten here so late.

La Fuente (The Fountain)

❧

On a beautiful spring afternoon in New York, I am joined at a "see and be seen" outdoor café by a young Linda Ronstadt–look-alike named Nina Casas. I am hoping to be put in a high-profile "post-Latino" (whatever that means) exhibition she is helping curate in San Francisco. I pray everything goes perfectly.

It doesn't.

She orders a "booh-kanas." The waiter is confused and calls for the maître d'.

Nina is from south Texas, Vassar-educated, art history major. Interested in border culture. Very social, big drinker. What in the hell is "booh-kanas"? I got it! The whiskey of choice at high-class Mexican weddings and art openings.

"She'll have a Buchanan's, please," I intone coolly. The maître d' doesn't miss a beat.

P.S. I got into Nina's show. But don't ask me what post-Latino means.

LADIES AND GENTLEMEN

I used to run a really great Mexican *botánica* in San Antonio. A *botánica* is one of those stores that sells candles, incense, religious statuettes, medicinal herbs, magic potions, and various knickknacks. My inventory was piled up to the ceiling.

One of my regular customers was an alabaster-skinned, raven-haired man with soft eyes like a dove. He bought my less expensive religious items (beat-up chalices, dilapidated Mexican candleholders). I had a crush on him. But he was so serious, polite, and straight-acting that I never tried to flirt with him.

One day he came into the store and, to my amazement, started talking. He told me he was a Catholic deacon in Silver Springs. He thanked me for the good prices I had always given him. I told him it was my pleasure.

He said the items he had been buying were for Father Compton, a beloved elderly priest who had baptized his parents. His voice softened into a whisper. He looked really shaken. He said the coroner had called that morning. The priest was dead. The cause of death was heart failure. And Father Compton was a woman.

The Powder Room

We are at the opening of a show I curated in North Texas. My friend Chuck guides me to what he is coyly referring to as the "powder" room—our cheerful hostess's double-sinked master bathroom. Sylvia Rosales is already in there. She's the one who brought the "powder."

Sylvia has recently discovered she's a *bruja* and can read palms. All night long she's been grabbing my palm and telling me, "I'm really sorry, guy, but you're gonna die soon. I'm really sorry." She does this even while I'm trying to relight the Sterno under the Velveeta Rotel dip. I snarl at her through gritted teeth.

I guess she knows I'm really pissed off at her, because arrayed before me is the most humongous rail of coke I've ever seen. Must be two hundred bucks' worth. Sylvia reverently hands me her favorite silver straw. *Oh, shit,* I think. *Maybe she's right.*

MOJADO (WETBACK)

I have become acquainted with a fastidious European photographer who wants to explore the world of cowboys in his new series. My coffee is just kickin' in and I open my big, fat, angry mouth and go on a rant about how those white, Roy Rogers western movie cowboys never really existed in South Texas. Most of the labor in these parts was done by Mexicans and blacks. "Nowadays it's wetbacks," I say, provoking him with that ugly word for undocumented Mexicans who sometimes resort to swimming across the Rio Grande in order to get work in this country.

The photographer does a gorgeous job photographing these guys, their baroque shacks, their pet peacocks, their favorite shirts, their junked cars. I can only imagine how helpful and polite they were to him, with their agreeable tea-party nods. But I don't see any of them at the show opening or the glamorous party that followed—only the Anglos who own the ranches they work on. Maybe I arrived too late. Maybe no one bothered to invite them.

Amarillo

No, not armadillo, *amarillo.* It means yellow in Spanish. Like that famous song, "The Yellow Rose of Texas?" Never heard of it? Let me tell you the story.

The Yellow Rose was a mulatto slave girl who lived in San Antonio in the 1830s, the era of the Alamo. The Yellow Rose passed for white, or "high yellow," as they used to say, and she was quite beautiful. Her luxuriant charms detained General Santa Anna just long enough for Texan troops to rally further north.

So while General Santa Anna won the Battle of the Alamo and even got to kill John Wayne, he eventually lost the war at San Jacinto. Texas became its own nation. Slavery, which had been forbidden under the Mexican constitution, was legalized in Texas. The Yellow Rose got the hell out of there. (She must have been not only pretty but also smart.) Legend has it that she headed north and became a prominent matron in high-class Boston society. I wonder if in some isolated spot in New England, the old Yellow Rose and the new Yellow Rose would secretly rendezvous, just to catch up and laugh about old times.

GERMAN CAKE

I betcha ten bucks you didn't know San Antonio was an old German town. The fancy King William district was originally the Kaiser Wilhelm district. After the wars, the Germans tried to pass as Anglos (like everybody else around here), but even today, high-class old-money San Antonio is full of—*shhh*—"German blood."

It's funny, but in my family the phrase "German blood" is always said in a whisper. Turns out we have some. Which explains why Aunt Tita and old Aunt Berta are six feet tall and spit out their Spanish like they're training rottweilers. And why Grandma Ruiz has baby-blue eyes, cold as a "cover the banana plants!" norther.

But our German blood doesn't get our family (or any of the other Mexican families with German blood) into the social register of San Antonio, nor into the elite debutante cotillions sponsored by the German Club. That's because we got our German blood way before the wars, and *way* after the late-night *biergarten* parties—in the bushes, under the stars, when no fancy German wedding cakes were looking.

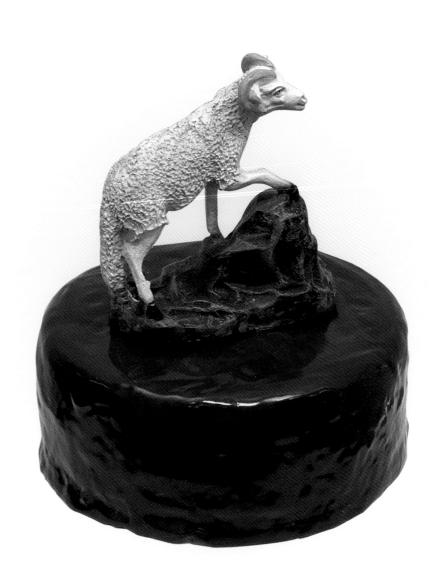

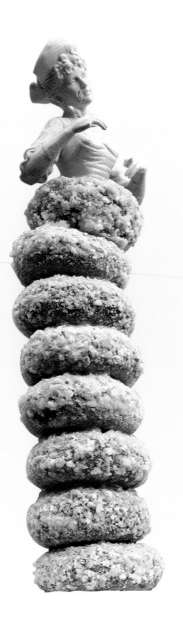

La Colosa (The Giantess)

✣

If you really want to know what my part of Texas is like, go rent *Giant*. It's just like that.

Full of Mexican busboys waiting for the gringos to clear out.

Except there are a lot more trees and a lot fewer James Deans.

And the Elizabeth Taylors here don't hold their help's sick babies.

And the Rock Hudsons here don't get in bloody-nosed fistfights over social injustice.

And the Elizabeth Taylors don't grow to love it and stay.

And the Mexicans aren't grease-painted Sal Mineos.

And the shacks aren't so far away from the ranch owners' houses.

And Edith Head doesn't do the costumes.

Love Story

＊

There are two things homosexual men absolutely cannot live without: air conditioning and ice. This explains why there were no homosexuals prior to the Industrial Revolution.

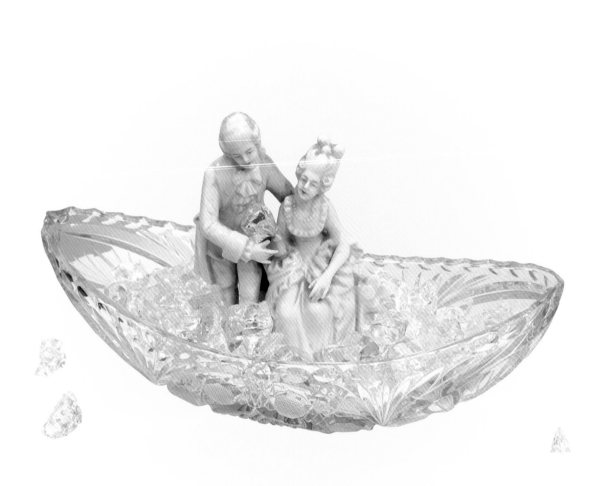

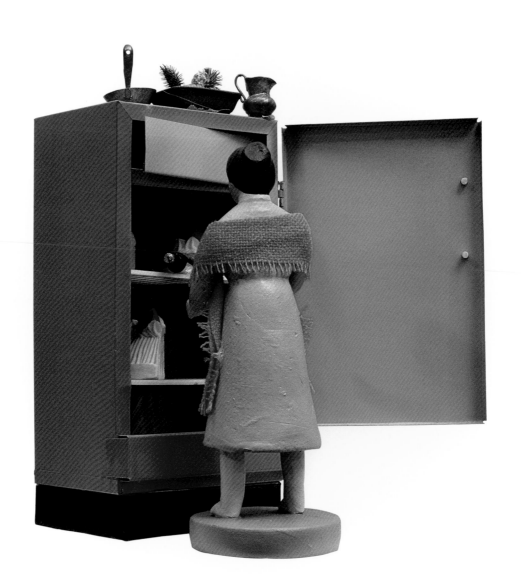

GRANDMA'S HOUSE

There has already been too much good stuff written about Mexican grandmothers and their houses. But my grandmother's house didn't really belong to her, so I guess I can write a teensy-weensy bit about it. It really belonged to her huge, smelly, obnoxious, obese, drooling, doo-doo—breathed, stinky-shoe, torn-up mattress of a giant poodle named Romeo.

I hated Romeo. He hated me. Case closed.

Until one day my mom says I need to be nice to Romeo because Grandma thinks he possesses Grandpa Ruiz's spirit. He even talks to her. I am so royally screwed!

But at least now I know who she is always buying those cakes and cooking those huge pots of *fideo* for.

El Campo (The Countryside)

I like to joke that San Antonio, my hometown, is the Paris of Béxar (incorrectly pronounced "Bear") County. In a bittersweet way it's kinda true, at least in the eyes of the country folk from dusty little towns like Big Foot, Pipe Creek, Dripping Springs, and Pflugerville.

One summer, my sophisticated artist-friend, Alejandro Díaz, lands an art residency in Zapata, which sports lots of colonial-era adobe houses, partially aluminum-sided, with gigantic satellite dishes on top. Alejandro is the coolest thing to hit this town since Circus Garza and their blood-sweating hippo. He wows the locals with his blunt-cut bob and his Kenneth Cole clogs. The fortyish elementary school principal is bedazzled when Alejandro tells her he is from San Antonio. Unlike her frumpy small-town underlings, she is in the know—a cut above. "The River Walk!" she bleats excitedly. "Golly! That city never sleeps!"

Nacho de Paz

✻

Of course I know that the Spanish version of "Silent Night" starts with *"Noche de paz."* But for some reason I get tongue-tied and sing *"Nacho de paz."* Even after three years of high-school Spanish, I'm pathetic. I think it's because my generation was taught early to be ashamed of our parents' "bad" Spanish. Spanish was my mother's first language when she was growing up, yet she was forbidden to speak it at school. "You'd get expelled from school if the nuns caught you speaking Spanish," Mom often told us.

When I tried to speak Spanish at home, Grandma and Mom would blush with shame and avert their eyes as if I were asking them where babies came from or why Uncle Karlos talked like a lady. In high school, white ladies with names like Mrs. Belvin, Mrs. Robinson, and Mrs. Schwartz tried in vain to beat the Spanish back into me.

These memories are a source of endless amusement to my friends from Mexico and my better-educated, blue-blood white friends, who can speak "good" Spanish. Like the time I ordered a plate of *huevos de ranchero* instead of *huevos rancheros*. The waiters and everyone at the table cracked up. A big ol' plate of rancher's balls for breakfast!

The El Jardin

It was the oldest gay bar in Texas. It closed a couple of years ago, after the San Antonio Conservation Society purchased the building. They're gonna "save" it. I can't blame them. It's a beauty, with its thirty-six-inch-thick limestone walls and everything. Probably dates back to the mid-1800s, or even earlier.

A lot of buildings in the old part of San Antonio are layered like Russian nesting dolls. A 1960s-era aluminum-sided building contains a 1920s Americana storefront, which was built around an 1880s German limestone livery stable, which houses two rooms of an 1830s Mexican adobe *casita,* which holds remnants of a 1790s stick-and-mud *jacal*, which was built upon a Pagaya Indian burial mound, which was erected over the debris of some-one's prehistoric lunch of pecans and cactus fruit.

The well-intentioned ladies of the Conservation Society will restore the building to what they perceive as its historical pinnacle, when it was the storefront of an industrious German peach grower's thriving business in the 1870s, or something like that. They will refresh its colors to juniper blue with cran-apple-red trim. Why can't they just restore it to what I truly feel was its historic apex—when it was the only place in town where you could score a dime bag and listen to Edith Piaf on the jukebox?

Pass the Butter

Is it the Navajo or the Hopi that revere gay tribe members? I read somewhere that they would give little children a doll and a bow and arrow. If a girl went for the bow and arrow, she was allowed to do the menfolk's activities, like be a warrior. If a boy went for the doll, he got to do women's work like grinding corn, beadwork, and all that kind of fabulous stuff. I think there's some truth to that.

When I was ten years old and in the Webelos, there was a competition among all the troops. Each scout was given a plastic bag full of nuts, bolts, string, wire, hardware, material scraps, and so on, and had to build his own object. My parents came to the competition ceremony, in the Saxon Hall of the Methodist Church. Other people's tables were laid out with elaborate models of drawbridges, cranes, submarines, and rockets. My entry was a "historical vignette" with no moving parts. Sweetly beaming up at my speechless parents was a teeny-tiny, bonneted pioneer woman happily churning butter in her cardboard cabin.

The Butt Hut

There was that time it seemed all right
To feast on a pretty boy each night.
Amongst the potions and perfume,
Behind the shoppe—in my velvet room.

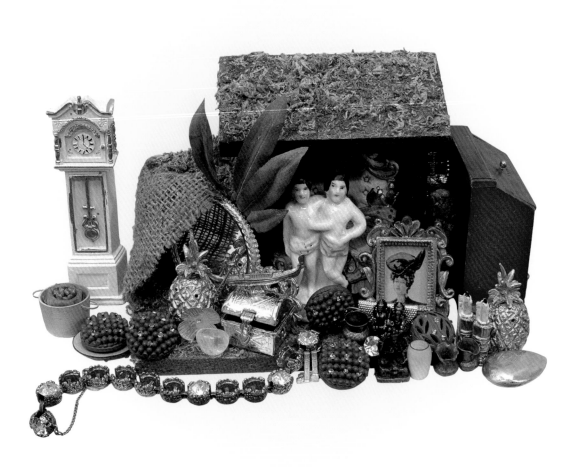

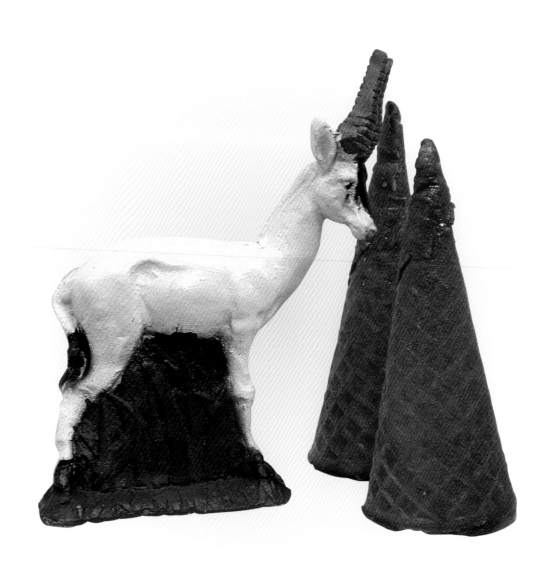

THE LOCKHORNS

✳

I was drained. So at thirty-nine I did something I thought I would never do: I went back to live at Mom's house. I didn't think it would be too bad, since she was living alone in my rich brother's almost new "starter home."

I moved all my best stuff into the house. Now all I had to do was get rid of her crap. Late at night I hauled out huge heavy-duty Hefty bags full of old phone books, junk mail, jars of faded and scentless spices, canisters of flea-and-tick powder (her dog, Maggie, had been dead for six years), grease-encrusted toaster ovens, enormous lavender Kotex boxes full of wigs and curlers, a giant sack of fast-food napkins, plastic spoons, ketchup packets, and the like. When I was done, the house gleamed of prosperity, of a life well-lived by a fine señora—a life I had always dreamed of for my mother.

For a while she let me think I was winning. My brother, sisters, nieces, and nephews were in awe. But Mom had been doing a little rearranging of her own, in the garage and a few closets I hadn't gotten around to. The wafting scent of Mom's victory hit me when, in the once pristine dining room, I stumbled over a four-foot-high pile of ancient, curled-up shoes smelling of Fritos.

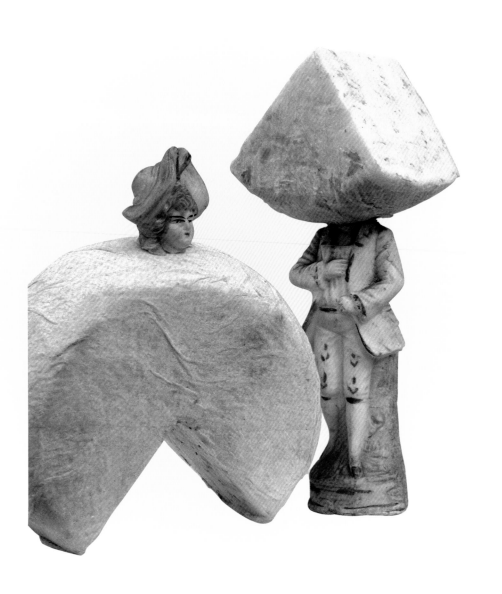

CHEESE PEOPLE

❧

They ask me what part of Mexico I'm from. Before I can answer, they ask me what my favorite Mexican restaurants are. I say *Rosa Mexicano* and *Matamoros*. And then I hear myself talking faster and faster, more and more nervously. I tell them, "But I'm actually Tex-Mex, and I haven't yet found the perfect Tex-Mex food here in New York."

Their smiles become frozen and fake. Their vibe changes. They respond with something like, "I just can't get over all that yellow cheese *they* use." And then, depending on how many drinks I've had, I launch into a diatribe about how Tex-Mex culture, while different from interior Mexican culture, is a valid and fascinating hybrid of contemporary Mexican and American cultures. They guffaw, think that I'm pulling their leg—and silently float away.

CHEESES OF NAZARETH

Today is family day at St. Bridget's Catholic Youth Camp. My family has come up to Jourdanton, in the Texas hill country, where I have been enjoying fellowship and testimony with my fellow young Catholics, most of whom I can't stand.

Mom has brought a picnic lunch. The food here is pretty vile, so I hope for something really good like fried chicken or even her lasagna. I'm starving.

But Mom has done it again, decided to surprise us. Our picnic lunch is a brown bag full of sweaty sandwiches made of white bread, longhorn cheese, and grape jelly. No chips, nothin'. The whole family is in shock. Dad goes ballistic. How I resent Dad's public humiliation of Mom. How I resent the combination of cheese and jelly.

What would Jesus do?

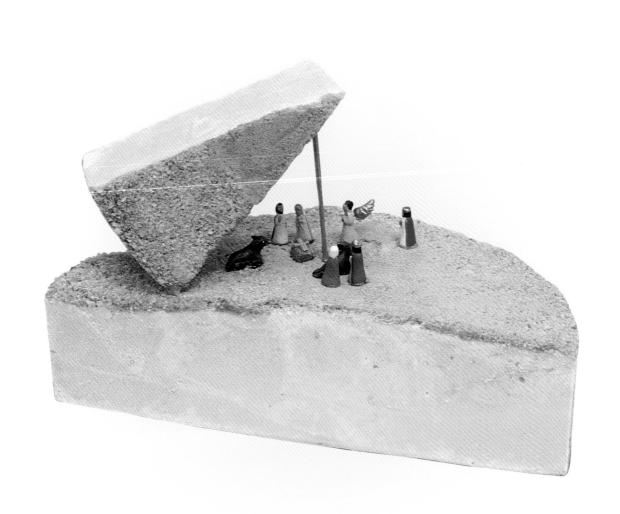

Historia de un Amor (Love Story)

Poor clueless Dad from a marble palazzo.

Poor clueless Mom from a house with no doors.

I guess they thought movie-star looks were enough to have in common.

And they lived unhappily ever after. Until the big split. After thirty years, Dad went back to his hometown *ragazza* (it didn't hurt that she had inherited two villas and lotsa lire). And Mom went back to being alone.

Poor clueless Dad from a marble palazzo.

Poor clueless Mom from a house with no doors.

Vienna Waltz

No one's gonna tell *her* how to cook spaghetti. Not even her brand-new husband from Italy. It's time to show him how things are done on the West Side of San Antonio.

She gets out the vermicelli, browns it really well in Wesson oil, and adds onion, chicken bouillon cubes, water, a bottle of ketchup, and, of course, the Vienna sausages—all chopped up.

"And she serves it to my friends from Italy," Dad says, blushing, as if it happened last night.

I hate that ancient story. My heart crumbles for my Mexican spitfire of a mom. My eyes sting at Dad's empty victory. I would so much rather hear about the time Mom spray-painted the refrigerator and all three pairs of Dad's shoes bright gold.

KEEPER OF CAKES

My mother's house is where cakes go to die. She sneaks them home in her purse and allows the refrigerated new-comers to lie in state in their Styrofoam sarcophagi and shrouds of tinfoil, amongst the curdling milk and bags of liquefied spinach. She lovingly tends to cupcakes that we are not allowed to touch until they self-implode after six or seven years. Her china closet is a reliquary of sugar doves long divorced and birthday cake flowers now with grand-children of their own. As a child I longed for a house like my friend Dean Lammert's, one with only a clipper ship on the mantel.

"If you like the Lammert's house so much, why don't you go live with them!" the Keeper of Cakes would taunt, stung by my dismissal of her handiwork, her incorruptibles—her jewels. But I know I could never leave a house where cakes go to die. And where donuts drop by just to sit and think.

Whatever Happened to Abraham Lincoln?

†

Whatever happened to Abraham Lincoln?

Whatever happened to Abraham?

Whatever happened to insane wives with a thousand pairs of gloves?

Whatever happened to slaves?

Whatever happened to Abraham Lincoln?

Whatever happened to *gloves*?

La Barca

The Mistress, also known as Tracey, is off to India, on her way to her glamorous opening in Shanghai. She is e-mailing chronicles of her colorful journey to her favorite disciples. Fortunately I have managed to remain on her list.

Jaipur, the Pink City. In an ancient perfumed garden, Tracey breakfasts with a couple of "poufs" (her Aussie word for gays). They are joined by an elderly European couple. The woman beams when she hears that Tracey is from Australia: "Oh, how lovely! Our son is there now and says, 'It is wonderful, Mommy, there are absolutely no black people here.'"

Tracey is part aboriginal and begs to differ. She tells the woman she's a bigot. The woman lacks a total command of English and optimistically assumes Tracey has said something friendly and "breakfasty" such as, "Could you please pass the marmalade?" But the man understand English and bids Tracey to "peesh off!"

Bombay. For three days, the gods of India entertain themselves by making sure that Tracey and this couple bump into each other wherever they go. In a fragrant, regal rose garden, Tracey pops up from behind a bush, sporting a Cheshire-cat grin. Tracey stabs the couple with a menacing wave from atop a bejeweled elephant. Her grinning head emerges from a snake charmer's basket. To the couple's horror, a sacred cow smiles sarcastically and winks at them.

Agra. Tracey spots the frazzled couple outside the Taj Majal, feels sorry for them and transforms herself into a statue of Durga, the goddess of compassion, with wide, startled eyes and mouth agape. The gray-haired couple passes, in hushed peace, hand in hand, into that monument of love, that temple of yearning.

What Should We Wish For

I must admit that Dad was pretty cool when I told him I was gay. As a matter of fact, he took full responsibility. He said that while Mom was pregnant with me, he kept calling me Little Francesca, even though Mom was sure she was going to have a boy. He says I must have heard him and got confused into thinking I was Little Francesca.

Agnes

❧

I love people who seem like they're from another time. The gorgeous Mormon boys on bicycles. The Mennonite family with marzipan faces and startled powder-blue eyes. The old lady in go-go boots. Love it!

The old man back home who used to stand around for hours on the corner of Hildebrand and Brazos, striking the same robotic Old West poses, rolling up his lasso, fiddling with an invisible tobacco pouch, waiting for a train that never came.

The hunky guy who looks like the mannequins you can still see in grimy shop windows in the old part of Mexico City. The long sideburns. The shiny black hair that seems like a toupee but isn't. The tight-fitting black three-piece polyester suit with the wide burgundy satin tie and pocket square. The chunky gold ring with the little diamond in the corner. My pulse quickens when I see him. He looks right through me, as if I'm the ghost.

And Mother Agnes. She used to bring her brood of eleven young 'uns to our house on special occasions. One day she was in a particularly good humor. She had shot two squirrels—enough to make a pie!

I Love New York

You know those stores near Times Square with those elaborate displays of electronics, cameras, luggage, and miniature World Trade Centers? Have you ever seen anyone buy anything in those stores? I live near Times Square, and I warn out-of-town visitors to stay away from those stores. But a couple of days before I have to go to St. Louis for a show, the zipper of my rolling suitcase busts. I spot an attractive brown piece of luggage chained to a pole outside one of *those* stores. I ask the salesman to unchain it so I can look at it. It's dirty. He leads me to the back of the store and shows me a red version. I politely tell him I want the brown one.

"The red and brown ones are exactly the same!" he responds impatiently.

"Fine," I say, "But I want a clean brown one."

He rants: "Who do you think you are? You think we sell dirty things? You come in here like you're some kind of fuckin' millionaire for a nineteen-dollar piece of luggage!"

He is starting to piss me off. I scream, "Fine, I'll take it as-is!"

He puffs up like a mustachioed cobra and says, "No, you cannot buy it."

My heart fills with hate. I am shaking. Eventually another man takes my money and unchains my luggage.

Breathe deep. Hold it. Exhale. Now slowly repeat: "I love New York. I love New York. I love New York . . ."

Las Damas

David Peterman and I are Gemini twins, born on June 2, 1961. In the 80s he hung around at the bars with white preppy boys dressed head-to-toe in Polo and I hung around with brown preppy boys dressed head-to-toe in Polo. But nowadays we have something even more monumental in common.

I was staying at his place in San Francisco and one morning he woke me up surprisingly early.

"Get up, honey!" he says, urgently, but sweetly, as if he's making waffles and doesn't want them to get cold. He is standing with his mouth hanging open and his hand on his cheek. "Something's going on in New York."

David Peterman and I were born on June 2, 1961, we were once caught in a dust devil together that almost tore our clothes off, and we were together when the second tower fell.

Taco Belle

If your baby were a crispy taco, you would

a) ignore the situation and hope others would also.

b) try to convince her she was not a taco at all.

c) *Revel in her splendors,*
 In her timeless, sculpted silhouette.
 Her graceful lunar curve,
 So perfectly and simply formed
 Of corn sweet, aromatic pearls of seed,
 Ancient and holy sustenance.
 Celebrate the mysteries of her taco scent.
 Of fragrant flesh, perfumed plump.
 Spices, herbs,
 Traditions of antiquity.
 Marvel at the verdant promise
 Of her lettuce bib.

d) devour her when no one was looking.

e) start a franchise.

f) all of the above.

g) none of the above.

Answer: a.

Don't Forget Where You Came From

�֎

My older brother looks a lot more Mexican than I do. He looks almost Polynesian. He looks a lot different from the rest of the people in Fair Oaks, his deluxe gated community.

But he's really made it, my CPA brother, and he loves nothing more than to barbecue ribeyes on the landscaped and bouldered banks of his three-tiered swimming pool. Each time I visit, I order my steaks more and more rare, hoping he won't start up again on his Republican thing. He brings it up about ten times per steak—even at medium rare! "As a Republican . . . As Bush said . . . If you were a Republican . . ."

I don't want to burst his bubble. He's so happy in his two-story house, in his Republican neighborhood, with its green, perfect grass and its rib-eye steaks, that he doesn't mind that when he stops his ride-on mower to welcome the new neighbors from California, they ask him to be their yard man. Before he can even introduce himself. Before he can shake their Republican hands.

He's really made it, my brother.

India María

India María is a Mexican folk heroine, a simple peasant woman with long braided pigtails who always outsmarts her vain, aristocratic employers. Not that her simple peasant ways don't drive them crazy along the way.

My friend Michael is an India María. But not all the time. Only when he is working for me. For money.

"Get up here immediately, we're late!" I hiss from my Manhattan studio.

"Okay, okay," Michael says, "I'll be there in half an hour." I imagine him daintily holding a toothpicked cube of gouda between his fingers.

"Half an hour?" I bark. "You said you were downstairs!"

"I am downstairs," purrs Michael. "In Brooklyn!"

La Zona Rosa

⚜

I met him at *El Taller* (The Workshop), a touristy gay bar in La Zona Rosa, the glitzy entertainment and shopping district of Mexico City. I should have been suspicious when he kept insisting that the taxi driver stop so he could buy beer. But I was too drunk to argue, and he was too cute.

I woke up naked the next morning on a wet mattress. My hotel room had been stripped of everything, including the phone, the bedding, the wastebasket, my toiletries, and every stitch of my clothing. *Oh my God! That guy slipped me a ruffie!* He could have cut out my organs and sold them on the black market. I counted my blessings.

Twelve hours later I'm back at *El Taller* and I spot the guy. I warn all my friends. He flirts with me. He doesn't remember my face. Adding to the insult, he's not even wearing one of my flawless new outfits.

Sell Me Something Brown

Drew and I used to rendezvous in Mexico City. We would hole up at the Isabella la Católica Hotel, a romantically dilapidated seven-floor extravaganza of wrought-iron balconied suites theatrically encircling a domed glass atrium. On the ground floor of this airy rococo birdcage was a diner where we loved to have a late breakfast and joke about the menu. Every item on it was hilariously mistranslated: "jam and eggs," "crippy becon," "chickens soap," "apple foot," and so on.

One morning Drew and I each order a "stock of pantcakes." A German man in the next booth is studying the menu. He looks bewildered. He places his order and minutes later a huge plastic bowl arrives, along with a small basket of corn chips. The man stoically devours spoonful after spoonful of the contents. His eyes bulge; he wipes his brow; he looks up at the ceiling and breathes deeply.

In our hungover daze, it never dawns on us to tell the poor guy that he's eating the hot sauce.

Slow-Poke Rodriguez

I'm home in San Antonio for a couple of weeks and I make the mistake of watching the local news. One of the top stories is that a new car dealership has opened in the South Side, a predominantly Mexican-American neighborhood. It's the first large dealership to be owned by a local Mexican-American.

C'mon, this shouldn't be a top story. You would think that in a city with twenty-five pages of Rodriguezes in the phone book, more than one of them would own a car dealership by now. But things happen really slowly in San Antonio. "That's what makes it so charming," they say.

Actually, not everything happens that slowly here. San Antonio holds the record for the youngest grandmother in the United States: twenty-one! I bet *that* didn't make the five o'clock news.

La Mojada (The Wetback Girl)

༄

After one thousand years of washing their clothes,
of cleaning their floors, of feeding their kids.
 After one thousand years of streets with no people,
of days without gossip, of a house without birds.
 She split.

The Disappeared

Somebody do something. I beg you. The sky really is falling. There really is a wolf.

In Ciudad Juárez, across the river from El Paso, someone is silently taking them. Grabbing them by their long black hair and pulling them into the desert. Raping them. Burning them alive.

Five hundred girls are missing. They have petite figures, factory jobs, and terrified parents. And no one is doing anything. Not the factories, not the police, not the U.S., not Mexico–not me. Well, the police in Mexico are doing something: They're claiming it's the girls' fault.

Somebody do something. I beg you. The sky really is falling. There really is a wolf.

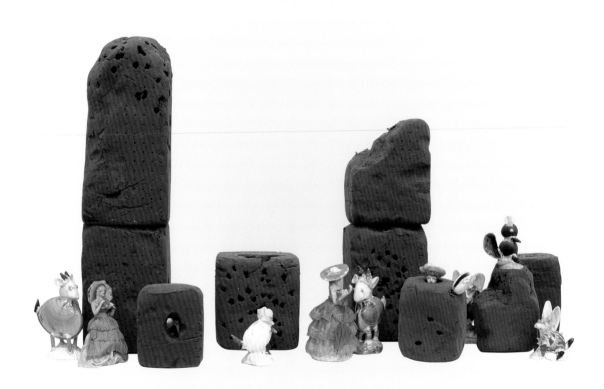

Vista Verde

It's very green where I come from. With envy, that is.

Jealousy and envy play a big part in the baroque intricacies of everyday life in South Texas. If someone says your baby is pretty, you *must* insist they touch it immediately; otherwise it can die or become cross-eyed. Best to err on the side of caution and have the baby wear a red string bracelet with an *ojo de venado* to ward off the evil eye. And always keep a strand of garlic wrapped in shiny red silk and a sprig of aloe vera over the door of your business, to ward off the envious.

Superstitions? Of course. But they are most decorative, these remnants of pre-Colombian, Chinese, medieval European, Gypsy, and Afro-Cuban survival strategies.

My friend Rudy sees the seventeenth-century bust I just bought in an antique shop. Rudy begs me to sell it to him. He offers double what I paid. I proudly refuse. He is wrecked; he comments on how the nose of the statue looks exactly like his.

I show him to the door, forgetting to have him touch the statue, as you should always do when someone covets something that belongs to you.

I close the door, turn around, and let out a startled gasp. My beautiful statue's nose is on the floor.

Mexican Museum

✣

When I was fourteen I went to Mexico City on a group tour with my older brother.

We're standing in front of a Diego Rivera mural at the Presidential Palace and a middle-aged, platinum-blond woman from Spain asks, in heavily accented English, "Why are the people in Mexico so little and brown?" And even though I'm from San Antonio, where a lot of people are little and brown, and even though I'm a straight-A student, and even though a lot of my mother's family is little and brown, I haven't a clue.

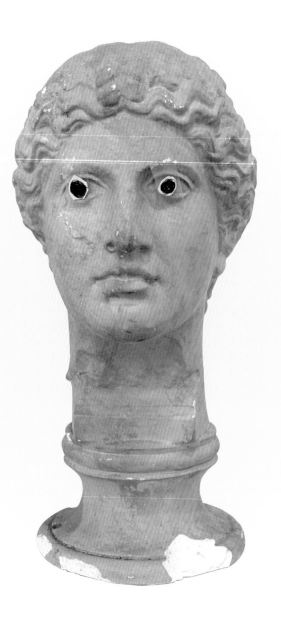

Panini

For Sandra

We weren't through yet.
Playing death.
In Venice.
I chose the role of plague.
And you, a burned-out heart.
When we were booed off the stage,
And it began to snow. For real.
Fíjate? Imagine that!
Snow and Mexicans in Venice.

ACUEDUCTO DE SEGOVIA

THE SNAKE CHARMER

I'm walking on a quiet street on the Upper East Side. Everything is so posh: the dark-green awnings, the white-gloved doormen, the topiaries, the fancy boutiques. A young man approaches. He is trim, in his late twenties, and very tan-not just his skin but also his eyes, his hair, his elegant suede pants, his silk Paul Smith shirt, his cashmere blazer, his neckerchief, his calfskin belt, his handmade shoes, his silk socks, his cappuccino.

As he walks by, I take one more admiring look at his golden glory. An innocent look. But that's not what he thinks. He looks straight ahead, as if I'm not there, unhinges his jaw, exposing his beautiful white teeth, and emits a long, menacing hiss.

PINK LADY

＊

She comes toward me with her little white towel to clean my shrinking pee-pee and I fess up. I tell her I'm gay and that the friends I'm with don't know it. They're in other rooms of the Papagallo, this pink neon, five-tiered, pagoda-shaped brothel in Nuevo Laredo. They're busy giving girls exaggerated fake orgasms, which is what I'm supposed to be doing right now. But instead I hide out for a thirty-dollar half hour, flipping through her magazines while she smokes her cigarette and tells me about her dream of opening an aerobics studio.

El Olivo

I can't believe Tony Hernández is *still* in the closet. Puh-*leeze*. He's nellier than me. Thinks he's too good to be gay. Like the time we're at a party and he says really loud,"Oh, wow, capers! I love these things." I guess we're all supposed to be impressed that he not only knows what capers are but loves them. Pinky extended, he daintily pops one into his mouth. I look away to hide my evil smirk. I know what capers are, and *those* are olive pits.

THE KISS

The first boy I ever did it with was a hustler. He stole my wallet. But I got even, without even trying, before he even stole it. You see, I told him I loved him the whole time we did it. And each time I said "I love you," he started to cry.

El Misterio

✦

I couldn't sleep last night. I started thinking about something I just can't figure out. It boggles the mind. And I wasn't stoned, I promise. It goes like this: You are one person. It took two people to create you. It took four people to create your parents. And it took eight people to create your grandparents, and sixteen people to create your great-grandparents. And to create them, thirty-two people; and to create them, sixty-four; and to create them, 128. And before them, 256; 512; 1,024; 2,048; 4,096; 8,192; 16,384, 32,768; 65,536; 131,072; 262,144; 524,288; 1,048,576; 2,097,152; 4,194,304; 8,388,608; 16,777,216; 33,554,432; and so on. Wouldn't that mean that a few thousand years ago almost everybody alive had to have been your ancestor?

My friend Rudy always thinks everyone he meets reminds him of one of his cousins. I guess he's onto something.

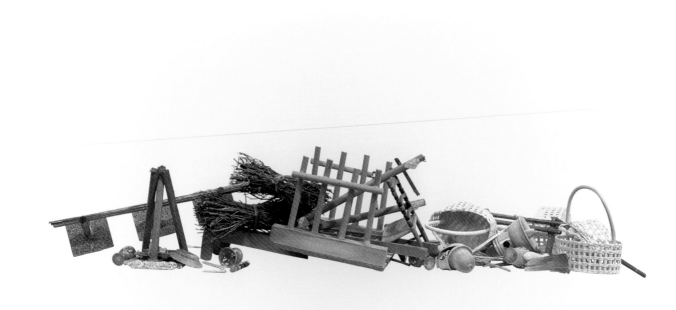

Mexican Junk

We are driving down Main Street in our full-of-junk, dusty avocado-green station wagon. Mom slows down. I look up from the Helen Keller autobiography I'm reading. *Oh, no,* I think, *she's spotted a yard sale!* The last thing we need in our house is more junk.

And it's not just any yard. It's the yard of Kate Wellborne, the richest, most stuck-up girl in school! To my horror, Mom rolls down her automatic window (which, just my luck, still functions) and shouts out to Kate: "How much for that **mir-row**?"

Kate looks up at Mom and says, "The **mirror** is not for sale, Mrs. Mondini. Our house just burned down."

Brownie and Whitey

In South Texas, a Caucasian person who is not Hispanic can be referred to by the following socially acceptable words: **"white"**; **"Anglo"** or **"Anglo-American"** (also includes Jews, Italians, French, Eastern Europeans, and so on); *"Gringo"* (slightly disparaging, unless said by a white person; then, charmingly self-deprecating); *"bolillo,"* or "white bread" (kind of a street term—a bit edgy); and **"Caucasian"** (a bit vague, since it technically includes Hispanics who are not black, Asian, or Native American).

A Hispanic can be referred to by the following socially acceptable terms: **"Hispanic"** (government-invented generic term describing people of all races of Spanish-speaking heritage—will piss off Chicanos); **"White Hispanic"** (government-invented generic term specifying that one is not Asian, black, or Native American); *"Chicano"* (politically flavored term embraced by some politicos, union types, politically conscious Latinos, artists, writers, academics— will shock Hispanic parents of Chicanos and offend Mexican nationals); **"Latino"** (Chicano lite—newer, hipper version, more inclusive, without the political edge and the sometimes misleading working-class and migrant-worker connotations); **"Mexican national"** (a rich person from Mexico); **"Mexican"** (a poor person from Mexico, or an older Mexican-American with strong ties to Mexico); **"undocumented worker"** (politically correct term for a Mexican working in the U.S. without government permission—do *not* use terms like **"wetback"** or **"illegal alien,"** no matter how often you hear them); **"Mexican-American"** (pretty safe term for Americans of Mexican

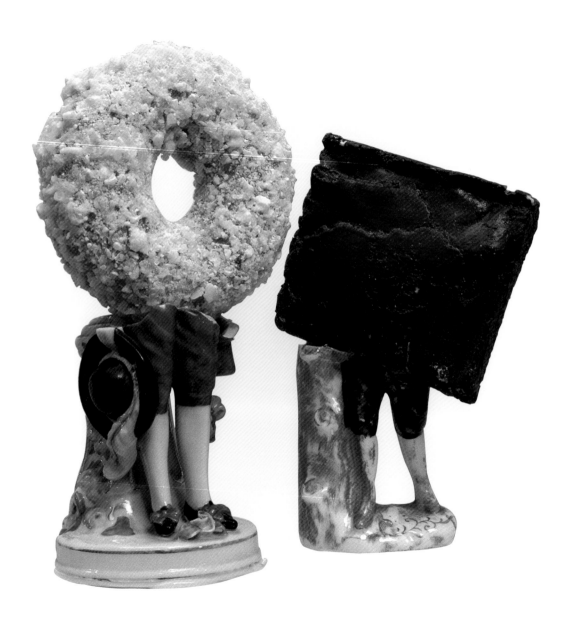

ancestry—will enrage Colombians, Dominican Republicans, Costa Ricans, Guatemalans, Peruvians, Spaniards, and so on, and is sometimes taken as a compliment by Iranians, Indians, Pakistanis, and Australian aboriginals); *"Tejano"* (a Mexican-American of Texan heritage—often sports Western wear or is a history or *conjunto* music fan); **"Spanish"** (a person from Spain, or a person of predominantly Spanish ancestry, or a Hispanic who is uncomfortable using the word "Mexican"); *"mestizo"* (comes up mostly in academic writings and refers to a Hispanic person of mixed race, usually indigenous and European, but can also include black, Asian, and other bloodlines); **"Latin"** (Latino lite).

Acknowledgments

A New York-sized *gracias* goes to the glorious army of people whose enthusiasm, support, talents, and funds allowed me to tell my story—and in color!

First of all, to my dear friend Simon Watson and his organization Downtown Arts Projects, who gave me my first New York exhibit and became the catalyst for getting this book published. To the staff and editors of D.A.P. who allowed an artist to write—Alex, Sharon, Avery and Lori—thank you.

A big thank you also goes to the financial support of the Creative Capital Foundation, the Penny McCall Foundation, New York State Council for the Arts, the Miller-Sweezy Charitable Trust, Ruby Lerner, Norman McCrary, Jennifer McSweeney, Kelly Ferrero, Andy Jacob and Kristin Austin, Maryanne Ellison Simmons, Wendy Goldberg, Beth Rudin DeWoody, David Shelton, Judi Roaman, Malia Simonds and Elliot Kirschner, Anne Wehr and Jason Sanders, Juan Garcia and Kelley Jackson. Thanks for allowing me to turn your green into high pink.

A very special thanks goes to my art dealer, Frederieke Taylor whose gallery and support have rescued me from obscurity and poverty and who has always allowed me to do my own thing as an artist.

A super-deluxe acknowledgment goes to my mentors and brainy friends who literally know where I came from and were able to give me the feedback and advice to "mostly" keep it real: Tomás Ybarra-Frausto, Sandra Cisneros, Tracey Moffatt, Miki Garcia, Alejandro Díaz, Victor Zamudio-Taylor, Annette Davey, David Davenport, Garrett Mormando, Craig Pennel, Todd Hanlon, Bill Garvey, Michael Marinez, David Casas, Naima Di Franco, Karlos with a "K", Rudy Lopez, Chuck Ramirez, Henry Muñoz, Julia Herzberg, Craig Hensala, and Dr. Antonia Castañeda.

Also acknowledged is the memory of my dear friends and sources of inspiration Danny Lozano, Drew Allen, Mark Luna, Carlos Gonzalez, and Bambie.

A final thanks to my family, friends, enemies, loves and strangers who have made me laugh, broken my heart, baked me a cake—given me a story.